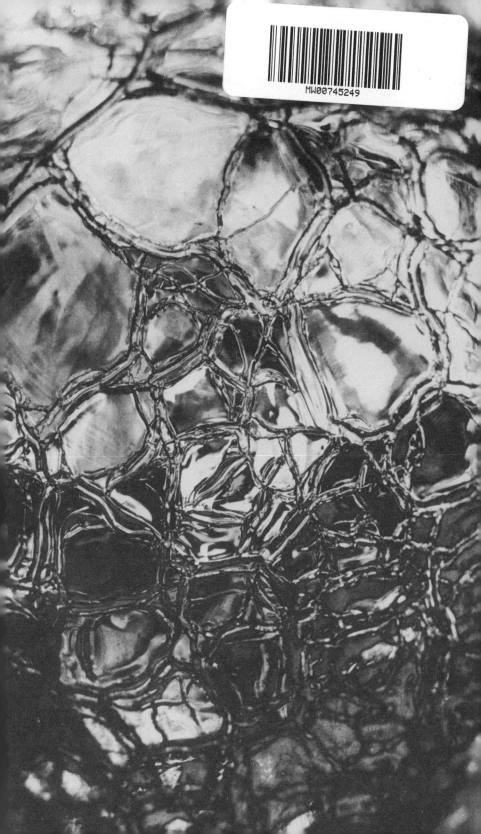

A

REVISION

O F

FORWARD

WENDY McGRATH

A

REVISION

OF

FORWARD

NeWest Press

Library and Archives Canada Cataloguing in Publication
McGrath, Wendy, author
A revision of forward / Wendy McGrath.
Poems.
ISBN 978-1-926455-37-2 (bound)
I. Title.
PS8575.G74R48 2015 C811'.6 C2015-901792-0

Cover and internal images supplied by Walter Jule
Editor: Douglas Barbour
Book design: Natalie Olsen, Kisscut Design
Author photo: Kylie Kennedy

Reprinted by permission of Farrar, Straus and Giroux, LLC: "The Poplar" from
The Spirit Level by Seamus Heaney. Copyright © 1996 by Seamus Heaney.
Excerpt from "The Card-Players" from *Collected Poems* by Philip Larkin.
Copyright © 1988, 2003 by the Estate of Philip Larkin.

NeWest Press acknowledges the support of the Canada Council for the Arts
the Alberta Foundation for the Arts, and the Edmonton Arts Council for
support of our publishing program. This project is funded in part by the
Government of Canada.

#201, 8540–109 Street
Edmonton, AB T6G 1E6
780.432.9427
NeWest Press www.newestpress.com

No bison were harmed in the making of this book.
Printed and bound in Canada

FOR

EAMON

BRENDAN

AND

CONTENTS

The time will come

when, with elation,

you will greet yourself arriving

at your own door, in your own mirror,

and each will smile at the other's welcome.

DEREK WALCOTT
"Love after Love"

DOMUS

x-ray still against the white wall
a stopped roan moth presses
a powdered clavicle curving toward
the blank and ragged silence of its wings
on the stairway
with its tiny window and wide sill

 ghosts dwell here
 lodgers under steps and risers
 where we stay when tornadoes pass over
 fingers spread on rough plaster walls of sand and hair
 imagine a fresco the colour of this moth
 the small tragedy of its short life

 these walls store the big comedies of our lives
 the slapstick of first steps or days of school
 these scenes rest alone
 in the small pocket of silence
 of storms past
 when we leave this house

NAUTA

a narrow ribbon curls purple
from the abandoned robins' nest in our backyard apple tree
ties me to Phoenician sailors and pent-up purple
of their nobly-shelled sea snails

the colour of sea and sunset
purple silk sails against water and sky
but I drown these slugs in salt
they foam and writhe under pocked primrose leaves

so many slugs
their trails circumnavigate our oil and paint-stained driveway
glisten silver white
cut the purple morning

buoyant on their own slime they float up the fence
against gravity those shell-less snails foul my garden
hide in crevasses and orgy under rocks

 raising the venetian blinds to a weakening sun
 I discover a trapped slug desiccated
 between the storm window and warm inside
 like fugitive mercury from a thermometer
 and think of purple

PECUNIA

there curse or kindness kissed into gold
coins marked and tossed into Bath's mineral pools
secret springs surrender those words
hurt, hate, revenge: rust to epithet

in downtown Edmonton earnest seems arcane
and the illustriousness of concrete
becomes the husk of the solstice
open as the handle of a cup

reflecting on the longest day
a boy traces a penny's raised numbers
the year of his birth embossed in copper
he feels lucky: says he wishes for nothing

> throws the coin into this slate-lined fountain
> just to listen for its sound

CABALLUS (FOR EDMONTON)

1905:

the russet birth of the first horse
smell of rust and blood
emergence from beneath the new town
where boardwalks and wooden saltboxes
flank the mud path that is Jasper Avenue

shabby men and women caught
walking to photographic infinity
their shadow faces already resigned
 to anonymous placement of bodies — their feet on the planks of dust
fashion shortens lightens the ghost images they will become

1965:

the birth of a second horse
a velvet nap
emerges from a dark shroud-split pavement
like skin
drawn in da vinci dissection

a sidewalk photographer
steals an image
in front of Kresge's downtown
buff coloured gloves and a matching chiffon scarf
her lips are red
I hold tight to her hand
wearing a white blouse I'm scared to wrinkle so I don't even smile
 remember ticket #659
 send money within 14 days

the horse is a dream of this city
a heartbeat and faith in wide asphalt streets
ghost sounds of soon-to-die buildings

the grey death of the last horse
hoofbeats beside Friday morning rush hour
on the wrong bus and we backtrack downtown
LRT from University station

gumby and pokey buttons pinned to my son's brown fishing hat
faces in the barrier of smoke-tinted glass and I barely know us
 we look like ghosts he says
 our images move forward from the last train car
 the horse disappears under the tracks

CARPENTER

he studies blueprints opened like sacred scrolls
and the flat of a carpenter's pencil sharpened with a knife
hovers over runic lines of stairs rooms doors and windows
he conjures solid walls from lines on paper

and the flat of a carpenter's pencil sharpened with a knife
estimates on scraps and pencils in numbers Xs and question marks
he conjures solid walls from lines on paper
the blue will release its ghosts

estimates on scraps and pencils in numbers Xs and question marks
then with hammer and nails he moves between two-by-fours
the blue releases its ghosts
and touches the lines on paper in hope

then with hammer and nails he moves between two-by-fours
remembering thick blueprint tablecloths corner-weighted
the blue releases its ghosts
ketchup bottle coffee cup salt shaker ashtray

remembering thick blueprint tablecloths corner-weighted
that illuminates the story behind those curling sheets
ketchup bottle coffee cup salt shaker ashtray
or a TV screen curving outward blue and warm on my palms

that illuminates the story behind those curling sheets
they come to mean nothing: like wood that shrieks from a plane
or a TV screen curving outward blue and warm on my palms
letters and words set foundations below the horizon

wood that shrieks from a plane comes to mean nothing
and his blueprints might illuminate some story behind those curling sheets
letters and words set foundations below the horizon
words beyond that blue sheaf mean nothing

and his blueprints illuminate a story behind those curling sheets
he hovers over runic lines of stairs rooms doors and windows
words beyond that blue sheaf mean nothing
he studies blueprints opened like sacred scrolls

OZYMANDIAS (EDMONTON, 1965)

those first-poured sidewalks hardened
higher than the clay dirt and sand beside them
snaked well in front of the basement rising from the earth
grey walls of concrete

waiting silent and porous
to hold the future sadness
of a pine frame bungalow
this was still the beginning of our family history

a small and simple house
was my father's works and we looked on
drank warm Coke and ate barbeque chips
then rolled down the basement backfill

 this high dirt hill
 already sprouting weeds

DILL

dill weed was a thief stealing space a squatter in the alley
though my grandmother loved this stowaway's crime
outside her garden proper she snapped its neck
a spray of green before going to seed in fireworks and bursting stars

 she'd picked dill on the farm
 into the pot a boiling underwater sway
 it caressed small red potatoes
 tore their thin fragile skin away

 she'd shoved dill into pickle jars
 with squat cucumbers carrots cut in sticks
 spice and pungent leaves
 in a hot brine of sun and fire

cold dill finds its way into our cart with the clank of a plastic container
I know dill as a twisted green coathanger that smells so familiar

LAMENT

scrabble tiles
and words bring us to table
 like the mosaic on the threshold
 of Pompeii's House of the Tragic Poet
 cave canem beware of dog

this simple scene from our daily life
is about to pass into shadow
this board's a mosaic of grieving vowels etched
letters words constructed and deconstructed
foretell a poem of loss

AMARE I

love is
the dream of snowflakes on a gun
melting to hate

gunmetal and snowflakes
water turns to rust
a twisted multiplication of elements

sometimes we sleep
through this allegory
and will not wake

AMARE II

so much of her love
measured in days
or maybe years she has known him

his awkwardness
hole in the heel of a black sock
patch of missed whisker under his chin

he has missed
the most complex piece
of her apportioned love

his embarrassment a small part
of the uncertain first seconds they met
when he stuttered on the first letter of her name

she knows now so much
of her love was pity
how he held his hat so shy

Our house rests on the ghost of a lake. We shop-vac a flooding
 basement
in an all-weekend downpour and its concrete floor becomes
 something else.

We are the new bog people. Me sacrificing Sunday to this seeping
 water and suddenly
you with your red hair and red whiskers, your face becomes
 something else.

The pickles are well-preserved. Nozzle to concrete I study small
 pock marks
on skin, splay of dill, pale green umbilical cord becomes something else.

The water table is out of whack. With no sump pump and no
 weeping tile
the mustiness settles on us heavy and dense and its sediment
 becomes something else.

My hands are cold. My flip-flops make red marks, cords on a
 bog-woman's feet.
Wendy, why is it with you everything always becomes something else?

we discover
three watches
in the kitchen junk drawer
soundtracks spring forward

Frére Jacques a lullaby
Life is a Cabaret a decadent lament
Beethoven's *Moonlight Sonata*
sadness rendered
in high-note peeps of a little chick

we wrap these songs
around our wrists
dance to the tune of lost time pieces
the strange music of each hour

SOLSTICE

a thin green caterpillar rappels from a branch
on a silk line of its own making
snaps the air with fish tail muscle

opens sky toward the longest day
this dawn an extravagant grey
still no inkling of sunset

> on trees repeating bark branch leaf
> on the useless song of an ice cream truck
> on a street without children

now steam on the window closes
toward the shortest day
the glass squeaks as Brendan writes HELLO

he plays the X-Files theme on piano with both pedals down
it is the 21st of December so we make note

my son brings home
a rented trombone
his friend brings a trumpet
and down to brass tacks

they play improv
just backyard discord
magpie-stopping
blasts

as the light flattens
their music flashes
as far as the weekend
they have no regrets

Play for the sky
Play for the sky

A CHRISTMAS POEM WITH MANY PEOPLE WRITTEN TO BE READ IN MAY

Brendan and I watch a Peanuts Christmas
40th anniversary remastered version
when I first watched it I was younger than he is now
and I learned Linus's soliloquy by heart
but the colours are strangely bright this year
a narrow halo of purple around Lucy's black hair
almost audible as the voices of frozen angel cookies in the freezer

 alternate between happy and sad

 40 years ago at the Community League May Carnival
 I ordered a sno-cone crazy
 with stained-glass splotches of cherry and lime syrup
 raised Christmas carols to my mouth and tasted their cold
 when John was a kid he listened
 to Nat King Cole's Christmas Song in May

 alternated between happy and sad

 in May I'll wish for Christmas
 that long weekend first few hot days of the year
 I'll wish for Christmas
 and to be naïve enough not to know waiting is the best part
 wish for Christmas
 venite adoremus venite adoremus venite adoremus dominum

 alternating between happy and sad

BALANCES

pines in repetition
bark bough and cone make shapes
that were always easy to imitate
if the assignment was: paint a tree
here on my street the pine
imitates a rooted rest for its cue
on a spiky out-of-balance pool table
it sucks the life from my purple rain birch
its stiff and leafless branches snap quick
 Wind shakes the big poplar, quicksilvering

we could smell the highbush cranberries
well before we saw them
cradling washed-out plastic ice cream pails
in early October but my mother could not
remember the way to the stand of trees
so we walked the river path taking measures
looking toward the scent of earth returning to itself
anticipating the red froth of berries in the pot
you pick so clean but look I pick so dirty
 The whole tree in a single sweep.

Hans Brinker and the Silver Skates
the winter book my mother read in the car
five hours to my grandmother's in Saskatchewan
my mother's voice would fall silent leaving us to sleep
inside the brittle dark the dashlights illuminating
the m-dash miles-per-hour and dashboard clock never true
the truth was the radio dial and AM branching overhead off-balance
between two provinces and shivering like poplar leaves we drove on
in and out of each other's range searching for a decent station
 What bright scale fell and left this needle quivering?

a question of trees branching histories and sounds
we leave nothing except what grew in the pines
or fell in those open-tilled spaces
I could tell you: people sometimes
can't make it out of the place before the first killing frost
talk sometimes rots on the branch
but here in my city yard I have hard-wire props
that train heritage-variety bush beans
and poplars are not allowed because their roots are insidious
 What loaded balances have come to grief?

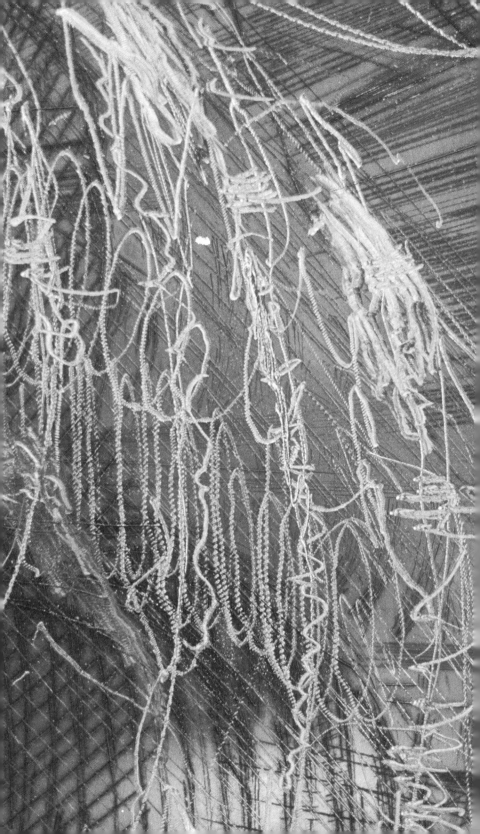

SURE, GOD IS DEAD

but in my office cube it's all creation talk
like how to make estrogen from scratch while microwaving lunch
or how daylight savings makes extra seem possible
so turn time ahead: create an hour of light out of winter darkness

sure, God is dead but you've got to admit
this three-letter word still adds a certain credibility to invocation
for the love of God bless us for God's sake God help us!
and you can still get satisfaction from a curse, Godammit!

Prayer: the act of and the person doing it
because even Bacharach-and-David said a few too
prayer's just talking to ourselves
who's never prayed for rain or, for rain to stop?

non-belief is still a belief in not believing
some might say sure, God is dead: just like Keith Richards

it was you
who found the mouth opening
to the birth of humanity
Mary Nicol Leakey
 Olduvai Gorge
 July 17th 1959
 from a deeper layer of Louis's life
Bed I: F L K (after Frida his first wife)

it was you
who salvaged the jaw
a mouth-roofed skull
a bowl that held
 your marriage
 turned to stone
 bone from rock
the intersection of three species (here was proof)

it was you
daughter of a painter
who reversed the process
and under canvas shade
 brush strokes and scratchings
 and *"Zinj" Dear Boy* was yours
 how eagerly you replaced flesh and blood
with his uncovered bones (another son)

KILRANE

mistake Kilrane for a storm eye
where sand and water burr stone
and seaweed boas document tide

its bitter cold denied today
we rush the freezing waves
breathless in Jupiter's wake

rung out and racing hard from shore
past unripe burrs on thorny green
these ditch pineries will boast tokens

when ripe and plucked sweet berries
each sweet berry sweet purple sweet
will sate our salt-borne thirst

HOOKS, CROOKS AND ONE-EYED JACKS

Jan van Hogspeuw staggers to the door
And pisses at the dark. Outside, the rain
Courses in cart-ruts down the deep mud lane.
Inside, Dirk Dogstoerd pours himself some more.

PHILIP LARKIN
"The Card-Players"

You're fuckin' crooked as a dog's hind leg
You're both in cahoots with each other
And let me see that deck
Some of those corners are gettin' pretty ragged
Goddammit then call the game
Hooks crooks and one-eyed jacks
So copper penny ante grows at the centre of the table
Dirt and sparkle at the same time
Like treasure inside a pirate's chest
Jan staggers to the door

Is this *The Potato Eaters*
Or some dark round table ritual
Where a beer cap is a prized talisman
And clubs, diamonds, hearts and spades foretell
The fortune of Jan, Dirk and the missus?
Bull-shit, horse-shit, hey chicken shit
Bet a nickel, c'mon bet a nickel
Ha-ha fuckin' right I will and I'll call ya too
Jan sways like a punching-balloon out to the porch
And pisses at the dark. Outside, the rain

Pours down turning the back yard dirt path to rut and mud
Call the game asshole: five card stud
Dealing cards and then quick: they're read like entrails
With a raised eyebrow or flick of the tongue a sniff a phtt
They all try to pull a bluff keep their best poker face
But the beer is gone and the 26 of CC under the sink
Hidden behind the "Joy"
Now promises even more joy but the missus worries
Dirk'll try to drive them home anyway and won't remember again
Bouncing in wheel-ruts down the deep mud lane.

Shuffle. Shuffle. Shuffle. Cut. A new hand.
But Dirk the dealer's already half-cut and flicks cards
That seem to have lost their magic and the talk turns
Remember when we lit our fuckin' farts on fire!
Ha! shot cow pies into the hay loft?
Fuckin' this, fuckin' that…and the missus has had enough
I'm driving myself home…then she remembers she lives there
All this for a few goddam pennies…have a drink
You don't need to throw away the cap. She puts on rain coat and
 rubber boots.
Inside, Dirk pours himself some more.

LIGHTS

there were no sirens
when Mr. Skrypnik was taken
if I hadn't seen the lights
I never would have known

when Mr. Skrypnik was taken
it was cold and the middle of the night
I never would have known
but I couldn't sleep

it was cold and the middle of the night
John was dead to the world
but I couldn't sleep
what did I have to be afraid of?

John was dead to the world
our sidewalk well-fed with snow
what did I have to be afraid of?
that window: limoges a crystal lamp

our sidewalk well-fed with snow
on this street of rusted mailboxes
that window: limoges a crystal lamp
I watched as they lifted him in

on this street of rusted mailboxes
Mr. Skrypnik grew sweetpeas every summer
I watched as they lifted him in
every day he wore a shirt and tie

Mr. Skrypnik grew sweetpeas every summer
his house had those old windows with wood sills
every day he wore a shirt and tie
at Halloween he always left lights on

his house had those old windows with wood sills
I never would have known
at Halloween he always left lights on
there were no sirens

FIXED

I knew someone who was afraid of bridges
he would lift his feet and hold them up
along the length of the High Level
he held his breath and fixed sights: for as long as it took

I wait for the weekend waterfall
to skirt off the bridge in this prairie city
men and women are overcome
fixed by a fake love song: give us a little kiss

I run through the bridge's weft and weave of light
through its shadows written beside me
under the track where trains don't run anymore
except that antique streetcar: fixed times only in summer
 rivets on every silken girder have fixed an alphabet of sadness
 and engineered its plea for mercy

1963 RAMBLER

my grandfather was a wheeler-dealer
and he ripped bits from the classifieds
snapped them under an elastic wrapped
around the sun visor on the driver's side of his light blue Rambler

he circled numbers in red and blue
called about transistor radios car parts and tools accordions violins
and guns
he brought home a present for my grandmother a porcelain deer
with a broken ear
the object sat on top the TV for awhile and then disappeared

the backseat passengers in the Rambler were piles of papers
a snowscraper jumper cables fishing illustrated and hunting illustrated
and UFO magazines with blurry photos of blobs above houses
Unidentified Flying Objects — those government shysters know all
about these things he said
checking the rear view mirror for anything sneaking up behind him
and fiddling with the radio dial

here's a good song *who stole the kishka* you know this one?
not like that other screaming on the radio that all sounds the same

THE DRIVE-IN

at intermission we looked out the open windows of our Galaxie 500
my mother pointed the tip of her cigarette toward the night and said:
there's the big dipper there's the little dipper they're constellations
I looked hard but couldn't see them
if you join the dots you can make them out
I followed the red of her cigarette and it was true
the stars made themselves into pictures
against the black screen of the sky

the movie ended
we drove away from the drive-in on the outskirts of the city
in a trail of tail-lights and tips of cigarettes headlights and stars
our new green car moving through the night crunching gravel
we were a constellation and we would be famous one day
like movie stars in our Galaxie 500

my father sits on the hood of his black '39 Ford with its grimace of
a broken grill his shoes thick and crepe-soled rest on the mound
of a bug-eye headlight the story my mother tells about the girl whose
slender legs hide the other headlight begins with:

she was the only girl in town with a bigger bust than me

every time my back was turned they would be kissing 'round some corner
I'd just about had enough and was going to tell him to hit the road
took all the things he gave me a silver ring with script engraved inside
a picture of him in a silver frame beside that old Ford...
piled everything on top of my dresser and when I saw the rear-view
of that pile of stuff in the mirror it was just a bunch of cheap crap
but it still made me better than the other girls because my boyfriend
worked out of town and drove down to see me every weekend

I opened the matchbook he brought me back from P.A.
put the ring back on and struck a match

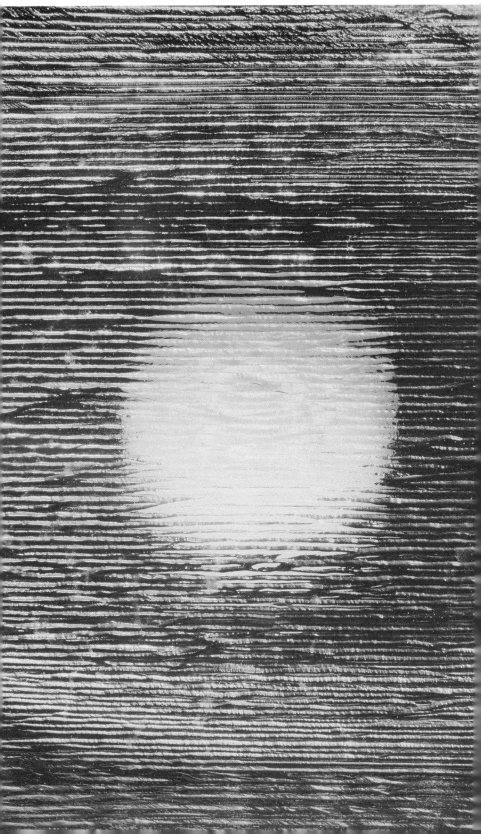

A REVISION OF FORWARD

stay want
hold a disappearing song
outside
the impermanence of water
the persistence of the moon
look the other way for a truth
not a thin-skinned lie
O love

O love
you are a thin-skinned lie
a truth told to look the other way
 persistence of the moon
 impermanence of water
outside
holding a song already disappearing
want to stay?

humming's indiscernible form
pulls longing from heart and throat

wish:
a husk that catches
beginning of breath
sleep deep enough to dream
these furrowed sheets
and how they became

furrowed sheets
with dream and sleep
and the beginning of breath
a husk of a wish that catches

a longing pulls the heart
humming an indiscernible form

this is love
a place beyond four directions
accepted destinations
yet love is but one letter away from lose

lose is but one letter away from love
destinations not accepted
beyond any place
this is lost love

four corners
four walls

flat surfaces marked by
 a handle on a door
 head of a nail

 a head of a nail
 the handle on a door

mark flat surfaces

four walls
four corners

a sheet of paper
becomes the meaning of stone
an answer to light and dark
a question of water or salt
a single tear
my heel marks
the edge of my soul
impressions set in cement
this is my lie
so let me tell it

let me tell it so
my lie
an impression in cement
the edge of my soul
a heel mark
a single tear
salt and the question: whether water
answers to light or darkness
finds the meaning of stone
on a sheet of paper

mis sing
 named
 conception
 take
 step

 step
 take
 conception
 named
mis sing

skin and ink
said you never played an instrument
but your fingers always acted
like they wanted to happen
a consequence?

happenstance consequently
like they wanted
to always act
fingers playing an instrument
your skin and ink

your fingers held the string
in hard-fought balance
dropped a plumb line
and begged keep still

 stay

stay

 still keep begging
 drop a plumb line
 with hard-fought balance
 your fingers hold the string

and the colour of your hair
was what I had been looking for
was what I had been looking for
the colour of your hair?

chalk
in a chance I never had before
a ghost of skin and ink
ink and skin

skin and ink
before I ever had
a ghost of a chance

bones of this bed
shape the secret
that forms the knot
of separation unmade

this bed is muscle and sinew
is joint coil and spring
joining and spirit
contract of a kiss

skin hair nails teeth of this bed
form the truth of telling
fortunes or lies

fortunes or lies
form the truth of telling
skin hair nails teeth of this bed

contract of a kiss
joining spirit
joint coil and spring
muscle and sinew

this bed made of separation
knots undone
shape the secret
bones of this bed

wire sculpture
is the art of the twisted wound
 the art of the twisted wound
 bodies metal
 shaped in implication
 spare of feeling
 parts leftover

 leftover parts
 a spare feeling of
 implications shaped into
 metal embodies
 the wound of twisted art
wound twisted art
wire sculpture

impossible to scrape
from under fingernails
just wait until its colour
wears away

away wears its colour
just wait
until from under fingernails
you scrape impossibility

sullied
with embellishments
want hangs

hangs wants
with embellishments
sullied

the shape of love
knotted into belief
hands harden around
this unknowing
an instinct to fear

to fear an instinct
this unknowing
around hardened hands
of knotted belief
a love of this shape

scales might balance connection
but mock any transparency
of elements moving toward metaphor

metaphor moves toward elements
of mock transparency
connection might balance the scales

small pebbles
colour of algae
dull against glass

dull against glass
colour of algae
small pebbles

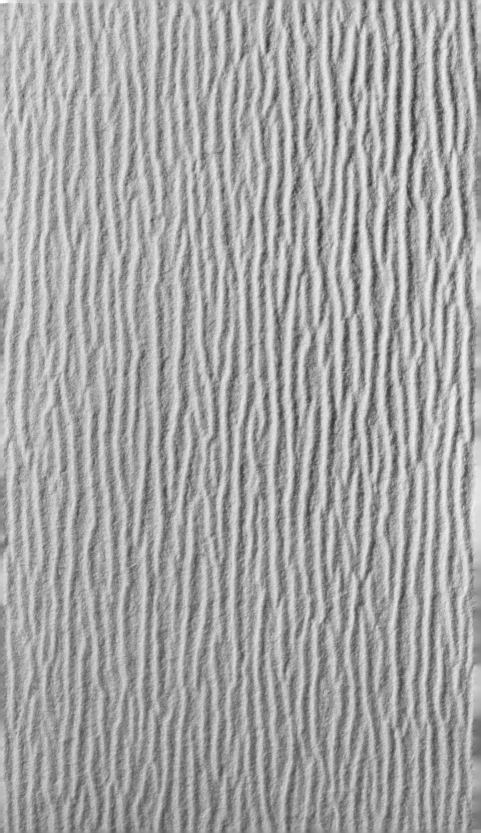

When teaching printmaking at the University of Alberta I would sometimes include a short "open" project around mid-term to give the students a break from the conceptual and technical rigour of the official course outline. One option was simply to ask each student to bring in an object they found either visually interesting or emotionally engaging that they could explore through drawing and printmaking. I used that approach in 1994 in a printmaking class in which Wendy McGrath happened to be enrolled. There was the usual worn tennis shoe, an album of family photographs and a fascinating collection of ephemera: broken watches, old coins, even an antique manual typewriter with keys akimbo. McGrath walked in with an armload of books. It was "the images inside the writing," she explained, that were to become the inspiration for her prints.

While I was aware that McGrath was an accomplished writer I was not yet familiar with her work. Nevertheless, her statement gave me pause and ultimately served as an inspiration for the creation of a new course at the University of Alberta specifically structured to explore the relationship between image and text, text as image and so on. "Word and Image" is still a part of the U of A printmaking curriculum.

As I became more familiar with McGrath's writing I was struck by references to memory (cerebral and haptic) of the physical world: particular shapes, colours, smells and an overarching sense of what I can only call the circularity of time, an intuition that past and present can be simultaneous without destroying the temporal sequence of before and after. Her poems were often like

time "collages" and seemed to echo my own interests as a visual artist including a preference to "circle" issues indirectly through the use of fragments and "mirror" images. Our collaboration began slowly, building on shared values and curiosity about how artists can use different means and mediums to approach similar ideas. It has evolved through the exchange of images and poems-in-progress and has resulted in a number of small exhibitions and, finally, into the series of print-works which combines word and image and accompanies this book in exhibition.

Collaborations of this kind work when the individuals involved harmonize at the boundaries of their own understanding, at the edge of their range like jazz musicians picking up on each other's solos and tossing ideas back and forth. They are successful when they enlarge the lyrical and harmonic possibilities while staying on the beat. Working with McGrath has prodded me to explore the integration of two and three-dimensional elements in my prints and installations and ask how seemingly unrelated images might find a coherent unity through association with the written word.

<div align="right">

WALTER JULE
June, 2015

</div>

ACKNOWLEDGEMENTS

When Walter Jule invited me to work with him on "a project," I could not have predicted the project would become a 15-year collaboration. Thank you, Walter, for your intellect and your inspiration.

Thank you, Natalie Olsen for your design work on the book *A Revision of Forward.*

Derek Walcott and Bert Almon facilitated writing master classes at the University of Alberta in 2009 and 2010 during Mr. Walcott's tenure as distinguished scholar-in-residence. Some of the poems in this collection grew out of that experience and I would like to express my thanks to Derek and to Bert.

Thanks to Doug Barbour. You have supported my work and encouraged me as a mentor and friend throughout the years.

Finally, I would like to thank my husband John and my sons Eamon and Brendan for great music and good humour.

Versions of some of the poems in this collection have appeared in the following:

"pecunia," and "domus" *The Acrobat* (Tightrope Books online magazine)(March, 2013).

"Sub terra" and "Caballus (for Edmonton)" *Descant* (Spring, 2013).

"tempus" and "Zinjanthropus boisei" included in the chapbook anthology *tempus* (Rubicon Press, 2006).

"A Christmas Poem with Many People Written to be Read in May" appeared in the *Edmonton Journal* as part of the Poetry Project (May 28, 2006).

A Revision of Forward is Wendy McGrath's second poetry collection. She has written three novels and her fiction, non-fiction, and poetry has been widely published.

¶ *A Revision of Forward* was typeset in Freight Text, designed by Josh Darden and published with GarageFonts in 2005. The unserifed face is Proxima Nova, designed by Mark Simonson and released by his studio the same year. The book was printed offset on FSC® certified Cougar Natural Smooth paper by Houghton Boston Printers.

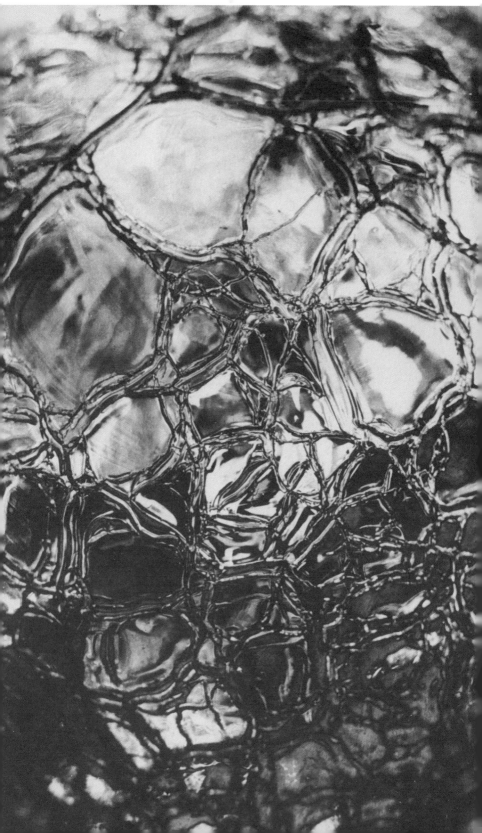